THE BRITISH MUSEUM
Chinese Calligraphy
Standard script for beginners

Introduction
Jane Portal

Text and calligraphy
Qu Lei Lei

THE BRITISH MUSEUM PRESS

First published in 2004 by The British Museum Press
A division of The British Museum Company Ltd
46 Bloomsbury Street, London WC1B 3QQ

A catalogue record for this book is available from the British Library
ISBN 0 7141 2425 7

Designed by Mustafa Ja'far
Cover calligraphy by Qu Lei Lei
Front cover: 'The way' (dao)
Back cover: 'If you want to see further, climb up higher'.
Typeset in Humanist
Printed in Great Britain by Goodman Baylis Ltd

Introduction

Although Chinese is spoken by more people in the world than any other language, there are many different regional dialects which are incomprehensible to people living outside the particular region. However, the Chinese script is the same regardless of the dialect, and this unites the Chinese-speaking world. In fact, it also embraces neighbouring countries such as Japan, Korea and Vietnam, all of which originally used Chinese script but which have now developed writing systems of their own, sometimes mixed with Chinese characters.

The earliest Chinese script was written on animal bones and tortoise shells from around the thirteenth to the eleventh century BC and recorded questions asked of the gods on behalf of the ruler. The bones were then heated and the resulting cracks interpreted to provide the answers to the questions. These characters incorporate pictograms and are irregular and quite unlike modern Chinese script. The next type of script was that inscribed on bronze ritual vessels from about the eleventh to the eighth century BC. First incised in clay moulds before the bronze was cast, texts in this script often record the reasons for the donation of the bronze to the owner.

When the first emperor of China, Qin Shihuangdi, unified China in 221 BC, he standardized the different forms of writing to create a regular script called small seal script or *xiaozhuan*, consisting of about 12,000 characters, each the same size. This was used for stone inscriptions and also on seals, which were very important in China both for showing ownership and for approving official documents. Seals carved with the owner's name were made of many materials, including bronze, stone, horn and wood, and were impressed into clay and later into red ink paste before being stamped on to the document or painting. Another type of seal script is called large seal script or *dazhuan*.

In the Han dynasty (206 BC–AD 220), with the development of paper and silk, clerical script or *lishu* replaced seal script on most official documents. It has also been found on bamboo slips, which were strung together and rolled up like a scroll. Clerical script, ultimately derived from seal script, is characterized by considerable differences in stroke width and by a prominent diagonal stroke running to the bottom right of each character. A more fluent form of this script also developed, in which the characters are often run together or abbreviated. This is called draft or cursive script or *caoshu*.

In the period just after the Han dynasty a semi-cursive version, known as running script or *xingshu*, came into use, in which the continuous motion of the brush links what had previously been separate strokes. Sometimes individual strokes are eliminated altogether or condensed. The convenience of running script made it very popular and it is still the most common form in everyday use. Around the same time, in the post-Han period, there evolved the script that is the focus of this book. This was called standard script or *kaishu*. It is the most sophisticated of any form of Chinese script, combining distinct individual strokes to

Chinese scripts

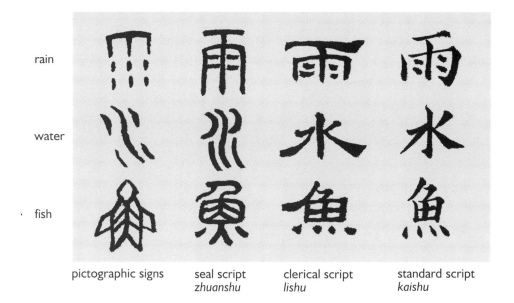

	pictographic signs	seal script *zhuanshu*	clerical script *lishu*	standard script *kaishu*
rain				
water				
· fish				

make symmetrically balanced and clearly legible characters, as opposed to cursive and running scripts which can often be difficult to read.

The most famous Chinese calligrapher, Wang Xizhi (AD 303–61), was proficient in standard, running and cursive scripts. His son, Wang Xianzhi (344–88), was also a great calligrapher but less renowned. Many calligraphers have based their work on the style of Wang Xizhi, as the copying of old masters has always been encouraged in China. During the Tang dynasty, masters such as Quyang Xun (557–641), Yan Zhenqing (709–85) and Liu Gongquan (778–865) perfected standard script. The invention of woodblock printing at this time meant that *kaishu* became the preferred form for printed books. Later master calligraphers include the eccentric Mi Fu (1051–1107), Zhao Mengfu (1254–1322) and Dong Qichang (1555–1636). Zhao and Dong used calligraphic techniques in painting as well as painting effects in calligraphy, showing the close connection between the two. As both calligraphy and painting are done with the brush, the disciplined use of the brush in calligraphy was considered a prerequisite to the study of painting. In fact, calligraphy was always held in higher regard than painting, and good calligraphy was traditionally associated with moral rectitude.

Many, but not all, Chinese characters developed from simple pictograms such as a man or a horse. Each character is based on a square and is made up of one part which indicates the meaning of the word (the radical) and another part that sometimes gives an idea of the sound (the phonetic). In traditional Chinese dictionaries, the radical is located first and then the number of additional strokes is counted to locate the character and its meaning. Chinese script was originally written vertically and from right to left, but these days it can also be written horizontally and from left to right.

The development of simplified characters or *jiantizi* in 1956 in the People's Republic of China was aimed at helping ordinary people to read and understand by reducing the number of strokes in many characters and often introducing simpler replacements, with the same sound, for complicated parts of characters. In modern China many people still like to practise calligraphy, both in the traditional and more modern, avant-garde styles and using both traditional and simplified characters. The line of poetry on the back cover of this book is written in simplified characters, whereas the rest of the examples are in full traditional characters. Large handwritten posters in enormous characters (*dazibao*) played an important role in the Cultural Revolution from 1966–76. Chairman Mao was himself an accomplished calligrapher and his handwriting still adorns the title page of the *People's Daily* newspaper.

Jane Portal
Department of Asia, The British Museum

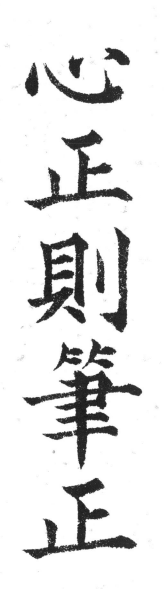

'Sincerity makes for correct brushwork'
Liu Gongquan (778–865)

The Four Treasures

Brush

Brushes vary hugely in size and in the type of hair, which can be quite stiff and dark such as wolf, weasel, badger or horse, or soft and white such as sheep or goat. Some brushes combine a stiff-haired centre, to provide a sharp tip, with a softer outside or belly to hold a quantity of ink.

For the beginner, a stiff-haired brush is easiest to control. As this was the type of brush used by the great calligraphers of the past, it is the most suitable for copying their work. The hair type or name of the brush is usually written vertically on the brush handle and beginners should ask for a 'large orchid bamboo' (da lan zhu) brush or a 'large white cloud' (da bai yun) brush. Check that the tip is sharp and that the belly is symmetrical and well rounded. For protection, the hairs of a new brush are held together by a water-soluble glue and sometimes a plastic or bamboo cap is placed over the tip. A new brush needs to be soaked for at least half an hour, and sometimes longer, in cold water to separate the hairs, and the protective cap should be discarded as replacing it can damage the opened hairs of the brush. The wet brush should be wiped to a point on a piece of cloth or tissue and left to dry flat or hanging from the loop at the end of the handle. When the brush is dry, shake it to separate the hairs and then store it, tip upwards, in a brushpot.

After use the brush should always be washed thoroughly in cold water–hot water may dissolve the glue holding the hairs in place. If ink is left to dry and harden on the brush hairs, the brush may be ruined.

Ink

Chinese ink is made from the soot of burnt pinewood, or oil smoke (lampblack), mixed with varying amounts of glue. The ink may be poured into moulds and dried to form inksticks, or it may be bottled as liquid. Bottled ink is fine for beginners, but there is something rather special about an inkstick and the calming ritual of grinding it on an inkstone before settling down to write.

Inksticks vary in quality and degree of decoration. In fact some inksticks are specially created as gifts or collector's pieces and are not actually intended for use. The creation of inksticks is an art form in itself. A beginner is reliant on advice, or price, but a good-quality inkstick should display certain qualities when in use. When wiped dry, the end that has been ground should be absolutely smooth and

have a purplish sheen. The ground ink should exude a musky fragrance. Good-quality ink should dry waterproof on the paper. The damp end of the stick should always be dried after use to prevent cracking or chipping.

Inkstone

The necessary partner to the inkstick is the inkstone on which to grind the ink. As with inksticks, these can be exquisite objects in themselves, often irregularly shaped and embellished with carving. One end usually has a deeper hollow for collecting the ink.

To grind ink, a few drops of water should be squeezed on to the flat surface of the inkstone and the inkstick held perpendicular to the stone. After grinding with a slow clockwise motion for two or three minutes, enough ink should have run into the hollow of the stone. Of course, the thickness and darkness of the ink can be varied by the amount of water used and the length of time spent grinding. If the ink is too thick it will not flow over the paper; if it is too thin it will bleed and make blotchy lines. It is advisable to buy an inkstone with a cover, as this prevents the ink from evaporating if you pause for a while. At the end of a writing session the inkstone should be washed and dried, and fresh ink should be ground when you next prepare to write.

Paper

The most obvious characteristic of Chinese paper is its absorbency. This can be alarming for a beginner, as the slightest hesitation when writing will cause a blot.

The best paper for beginners has a smooth surface and is treated to prevent the ink spreading too quickly. Sometimes this paper is printed with squares, often subdivided for ease of copying (see page 26). Two suitable and relatively inexpensive types of paper for calligraphy are mao bian and yuan shu, both of which are brownish in colour and composed predominantly of bamboo fibres.

More experienced calligraphers work on xuan paper which is softer and more absorbent. Although most Chinese paper feels very thin, it is in fact stronger than it looks for it is made of long fibres. A piece of finished calligraphy will always have an additional piece of paper pasted to the back of it before the whole piece is mounted on silk. This process of 'backing' the paper makes the finished piece smoother and stronger and somehow gives the written characters a very crisp definition.

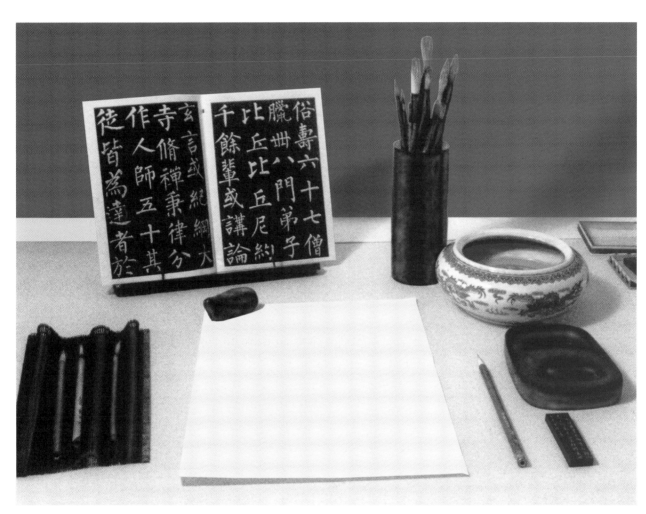

The writing table set for a right-handed calligrapher. If you are left handed, reverse the setting.

Setting up the table

The writing table pictured here shows the traditional tools and materials. These are of course ideal, but they can be expensive. For the beginner there are alternatives.

It is wise to invest in as good a brush as you can afford, of the type mentioned above. An inkstick and inkstone can wait. Bottled ink is fine for beginners. It is useful to have a shallow dish or saucer into which to pour a little ink.

The brush can easily be dipped in this and then excess ink wiped away, either on the edge of the dish or on a piece of cloth or tissue. The edge of the dish is also useful for stroking the brush to a point regularly while writing. If you are using an inkstick and stone, a Chinese ceramic waterdropper or a small squeezy bottle is handy for allowing just a few drops of water on to the stone. Suitable alternatives to Chinese paper are unprinted newspaper or even a printed newspaper itself!

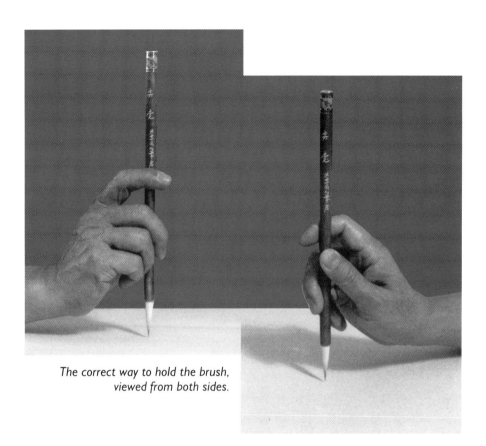

The correct way to hold the brush, viewed from both sides.

Taking up the brush

'Sincerity makes for correct brushwork'

These words, written by the great Tang calligrapher Liu Gongquan, are displayed on page 5 of this book. They illustrate how the term upright (*zheng*, second and fifth character) in both its physical and metaphorical sense, is central to the practice and theory of Chinese calligraphy.

The brush, as can be seen in the photograph, should be held upright, at right angles to the paper. One's body should also be upright: the back erect, with right angles at the hips and knees, and both feet firmly planted on the floor. A vertical axis should run through the body, and through a piece of writing: however varied the angles of many of the brushstrokes, the vertical stroke should remain vertical.

Holding the brush

In the standard brushhold shown (*zhi bi*), the brush is clasped firmly by the thumb and three fingers, with a hollow between them and the palm of the hand. The pinkie serves as support. The wrist may rest on the table or paper but should be free to move. With this hold the brush can be manoeuvred in any direction, thus allowing the 'way of the brush'. The brush should always remain vertical although it may be held at different points higher or lower on the shaft, depending on the size of the writing. Also, the angle of the wrist may change in much the same way as a violinist varies the angle of the bow.

Manoeuvring the brush

The next step is learning how to manoeuvre the ink-loaded brush on paper to create the desired forms. Experiment with simply moving the brush in the air, up and down, from side to side, round and round, and you will quickly realize the potential for movement. As well as directing the brush, you have to learn to exert varying degrees of pressure on the tip to create the contrast between thick and thin parts of a stroke. By pressing down you make a thicker mark, and by raising the brush a little you make a thinner stroke.

At the beginning you may find it difficult to think of all these points as you try to form a stroke. The absorbent paper leaves no time for hesitation! It is best to make a start and not allow yourself to be discouraged. Dip the dry brush into the ink and wipe off the excess, at the same time as turning the brush to maintain a sharp point (this must be repeated often while writing). A useful tip is not to overload the brush – the plump belly of the brush will hold enough ink for quite a few strokes.

The type of script you are about to learn is standard script (*kaishu*), which is the best one to start with as it provides the foundation for all other scripts. It is only by constantly looking and copying and practising that you will make progress. And by trying to make the strokes yourself you will quickly learn to appreciate the beauty of the strokes made by the great masters (see Gallery on pages 28–31).

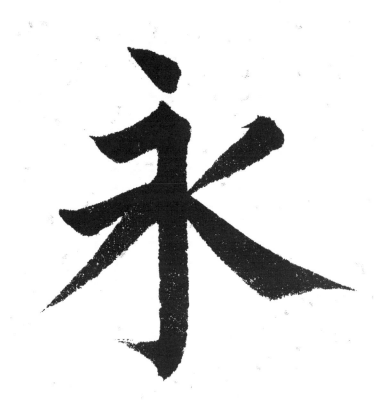

Modern Chinese characters have evolved over the ages, gradually undergoing a process of unification and standardization. However, there are still many disagreements as to the precise formation of many of them, which accounts for the ambiguities and contradictions to be found in books on calligraphy.

One of the earliest attempts to classify the strokes of standard script or *kaishu* was made by Wang Xizhi (303–61), who is considered by many to be the greatest calligrapher of all time. Wang Xizhi's teacher, Lady Wei, differentiated seventy-two types of stroke. Wang simplified her classification to eight strokes, all of which he identified within the character *yong* (eternity).

His book *The Eight Ways of the Character yong* has been much studied, and his theory can still form the basis of study for calligraphers today.

9

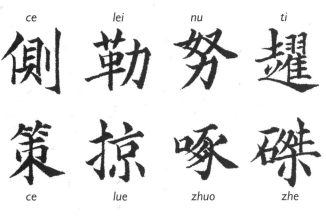

The eight ways

The original eight ways – or brush movements – necessary to create the character *yong* are:

1 *ce* (to shove) 5 *ce* (to whip)
2 *lei* (to rein in) 6 *lue* (to sweep)
3 *nu* (to incise) 7 *zhuo* (to peck)
4 *ti* (to kick) 8 *zhe* (to slash)

The eight strokes

The numerous brushstrokes in Chinese calligraphy can be condensed into eight basic strokes:

1 *dian* (dot) 5 *gou* (hook)
2 *heng* (horizontal) 6 *zhe* (bend)
3 *shu* (vertical) 7 *pie* (left sweep)
4 *ti* (lift) 8 *na* (right sweep)

Stroke One: Dot (*dian*)

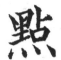

The dot is the source of Chinese calligraphy, and all strokes can be said to come from it.

The top dot stroke begins with 'hiding the tip' and ends with the 'return of the tip'. Start by moving the tip of the brush upwards. Then press down towards the bottom right.

Next, rotate the handle of the brush very slightly, keeping the tip in the centre. Complete the dot by lifting the brush off the paper.

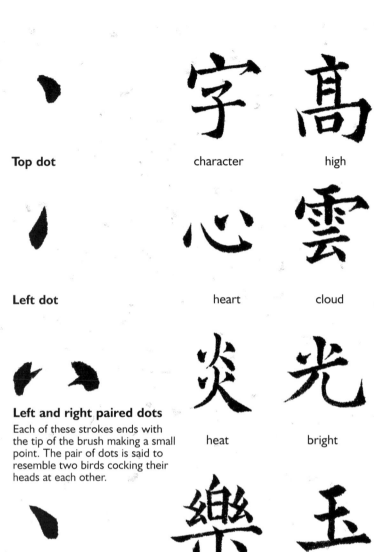

Top dot 字 character 高 high

Left dot 心 heart 雲 cloud

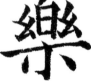 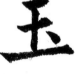

Left and right paired dots

Each of these strokes ends with the tip of the brush making a small point. The pair of dots is said to resemble two birds cocking their heads at each other.

炎 heat 光 bright

Stone dot 樂 happiness, music 玉 jade

Elongated dot 歌 song 不 not

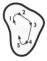

Top dot
brush movement

The action made to create this stroke is said to be like reining in a horse.

To make a short horizontal, begin with an upward movement, then press down on the tip. Rotate the shaft anti-clockwise while lifting slightly, followed by a movement of the tip to the right. End the stroke with a small movement to the top right, then press down.

Finally rotate the brush clockwise and make a quick flick of the tip to the left to finish.

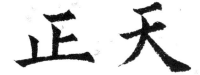

Short horizontal

upright heaven

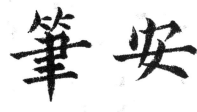

Long horizontal

brush safe

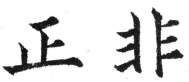

Left-pointed horizontal
Before touching the paper, move the brush to the left.

upright not

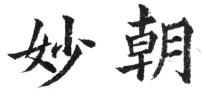

Right-pointed horizontal
On completion of the stroke, lift the brush off the paper and make a slight movement to the left.

amazing dawn

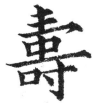

Right-hooked horizontal
The hook or flick at the end of this stroke is visible, yet merges in with the horizontal.

character longevity

Short horizontal
brush movement

Stroke Three: Vertical (*shu*)

This is a powerful stroke, created by keeping the brush vertical and moving it slowly and deliberately, like drawing back an arrow before releasing it from the bow.

To make a straight vertical, begin by moving the tip of the brush upwards, followed by a downward pressure and a small clockwise rotation. Then move the brush straight down. Pause before rotating the tip clockwise to move the tip back up the stroke. Lift off.

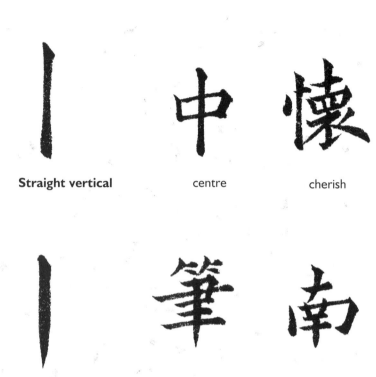

Straight vertical

centre

cherish

Sharp-bottomed vertical

brush

south

This stroke is made in much the same way as the straight vertical, except that the brush continues straight and is lifted off at the tip of the stroke.

Sharp-headed vertical

wait

emperor

Straight vertical
brush movement

Short vertical (iron column)

this

bright

This is a triangular stroke. Each version points in a different direction, but each begins with heavy pressure and ends with a light lift off.

To make a squat lift, begin slowly and deliberately by pressing down directly over the tip, then rotate the brush ever so slightly in an anti-clockwise direction. When you are ready, flick off.

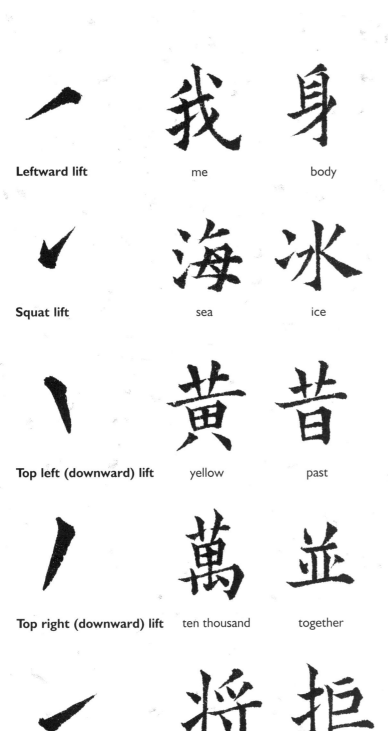

Leftward lift　　　　me　　　　body

Squat lift　　　　sea　　　　ice

Top left (downward) lift　　　　yellow　　　　past

Top right (downward) lift　　ten thousand　　together

Rightward (diagonal) lift　　general　　　　refuse

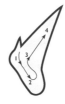

Squat lift
brush movement

Stroke Five: Hook (gou)

The brush movement for the centre hook is the same as for the straight vertical stroke until the end, when the tip of the brush is lifted off to the left.

The right-flicked hook is a combination of the straight vertical and the squat lift.

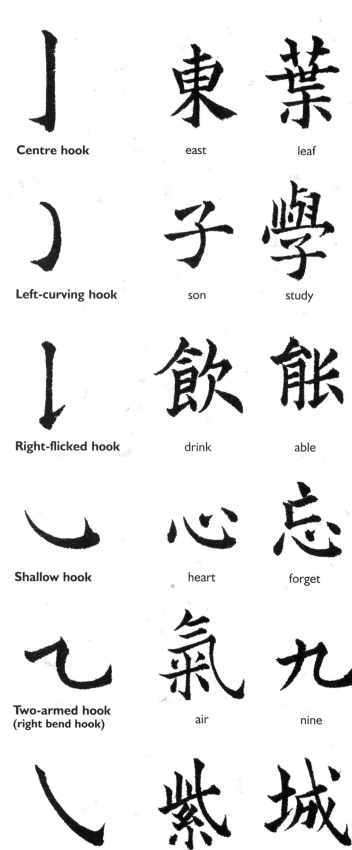

Centre hook

east

leaf

Left-curving hook

son

study

Right-flicked hook

drink

able

Shallow hook

heart

forget

Two-armed hook (right bend hook)

air

nine

Long slanted hook

purple

city

Right-flicked hook
brush movement

The bend may actually look like two or three strokes, but it is in fact only one, with a 'shoulder'.

When making a straight-armed bend, at the end of the first part of the stroke, gently raise the tip (without leaving the paper) and then press down with a slight rotation towards the direction of the next part of the stroke. Continue with the rest of the stroke.

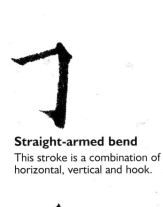

Straight-armed bend
This stroke is a combination of horizontal, vertical and hook.

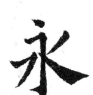
then

country

Left-slanted bend
This stroke combines the lift and left sweep.

eternity

source

Three-corner (zig-zag) bend

and

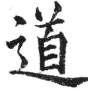
way

15

Right-slanted bends
These combine the left sweep and (top) the rightward lift and (bottom) the long dot.

dark

safe

Elbow bend
In this stroke a vertical is connected to a horizontal.

north

century

Straight-armed bend
brush movement

Stroke Seven: Left sweep (*pie*)

This stroke is usually known as the knife or sword stroke.

The difference between the left sweep and the lift is that the sweep is slightly curved.

Short left sweep enter but

Left sweep
Often the middle section of this stroke is slightly thicker than the beginning and the end.

house celebrate

Central left sweep
This stroke begins like a vertical and then sweeps out to the left in a curve.

heaven peace

 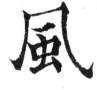 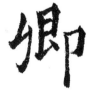

Hooked left sweep
This sweep is rather like a hook. Flick the tip upwards at the end of the stroke.

wind official

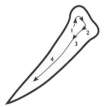

Short left sweep
brush movement

The right sweep can be long or short, thick or thin, but it always slopes and is fairly flat. It is made in a continuous movement with changes in pressure.

The distinctive feature of the right sweep is that one edge of the stroke is almost flat while the opposite edge forms a triangle.

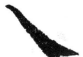

Deep right sweep

This stroke should be executed with confidence. The hand should not stick to the paper and the whole arm should be free to move.

large

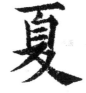

summer

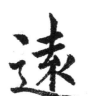

Shallow right sweep

This stroke is not straight but like a wave. There is a saying: 'One wave, three curves'.

distant

of

Reversed right sweep

This stroke looks similar to the elongated dot. In most cases the reversed right sweep can be used in place of the deep right sweep.

food

deep

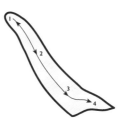

Deep right sweep
brush movement

Composition of characters

As soon as you feel comfortable with at least some of the individual brushstrokes you should move on to write characters, as this aspect of calligraphy is every bit as important as the formation of the strokes. Each stroke must be in the correct position and in the correct relationship to the other strokes forming the character. It is therefore essential to understand the different ways in which characters are composed.

1 Independent characters

These characters are each one independent unit and cannot be broken down into separate components. The area occupied by each character, which includes the space around it, is the same, although the number of strokes may vary. Characters composed of fewer strokes are usually written smaller to achieve balance over the whole page.

Whatever the size of the character, it is important to give it a stable centre.

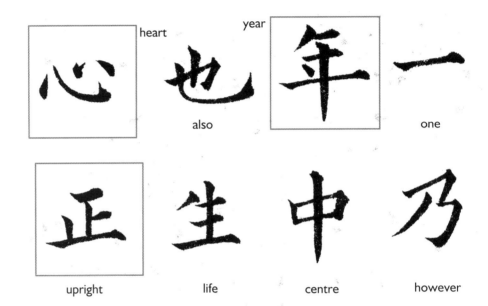

heart

year

also

one

upright

life

centre

however

2 Characters divided vertically into two parts (left-right type)

This type of character is composed of two parts, left and right, one of which is the radical. For example, any character denoting a tree contains the radical for wood.

The two parts of the character should be balanced but need not be the same size.

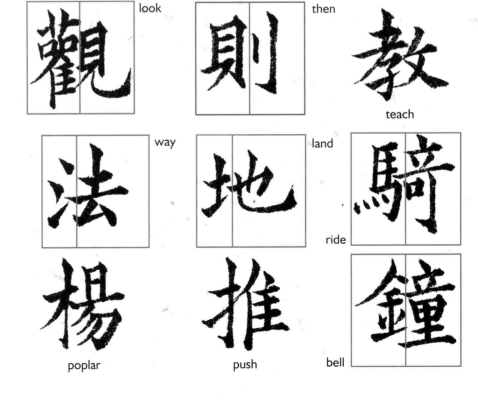

look

then

teach

way

land

ride

poplar

push

bell

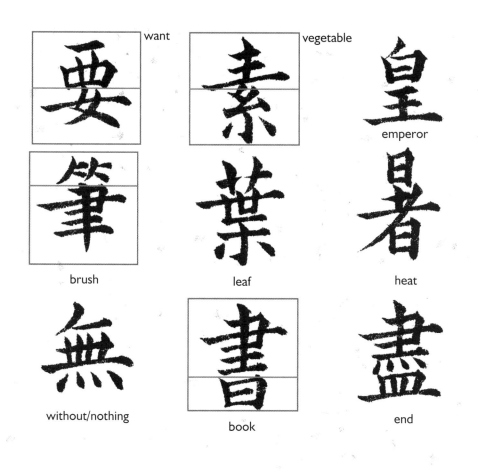

want

brush

without/nothing

vegetable

leaf

book

emperor

heat

end

3 Characters divided horizontally into two parts (top-bottom type)

In characters of this type the radical is either at the top or at the bottom. For example, characters for all types of fruit have a grass radical at the top.

The distance between the horizontal strokes should be equal. If there are many strokes, the spaces should be smaller. Avoid making the character too tall.

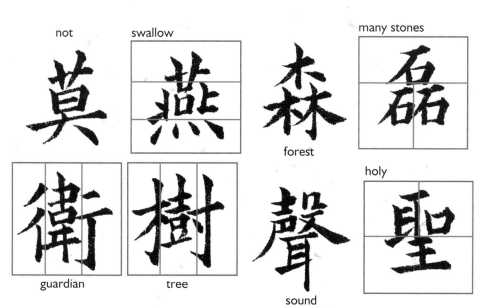

not

swallow

forest

guardian

tree

sound

many stones

holy

4 Three-part characters

The divisions in three-part characters may be vertical or horizontal, or a combination of both.

Care is needed to achieve stability and balance when forming these characters.

Composition of characters

5 Semi-enclosed characters

In characters of this type one part is enclosed by another, either at the bottom left, top left or top right, but never the bottom right.

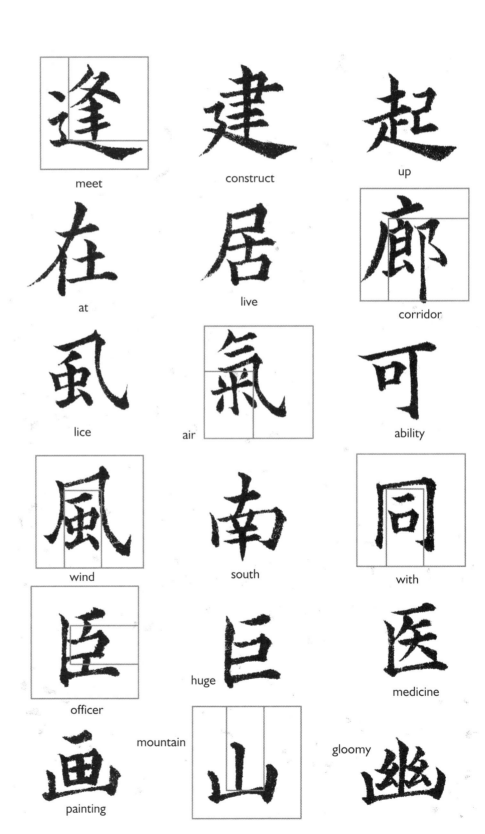

meet

construct

up

at

live

corridor

lice

air

ability

6 Three-quarters-enclosed characters

These characters are enclosed on three sides. Care should be taken to ensure that the proportions are in keeping with the number of strokes, so that no part is too large, too loose or too crowded.

wind

south

with

officer

huge

medicine

painting

mountain

gloomy

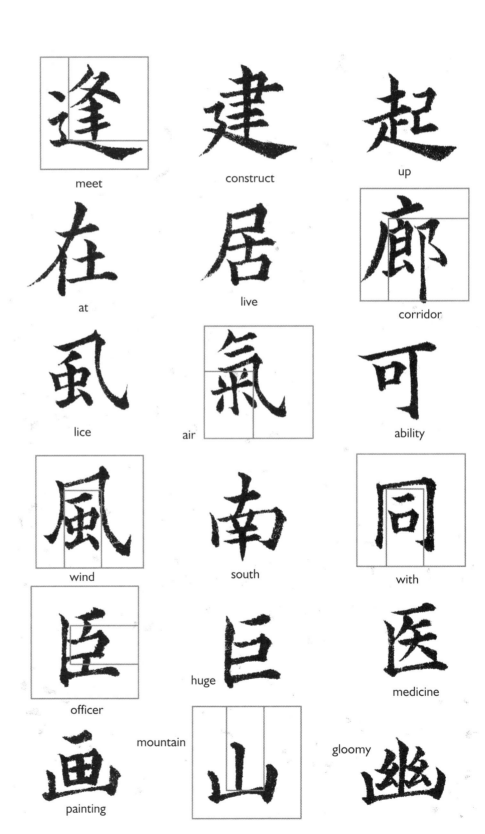

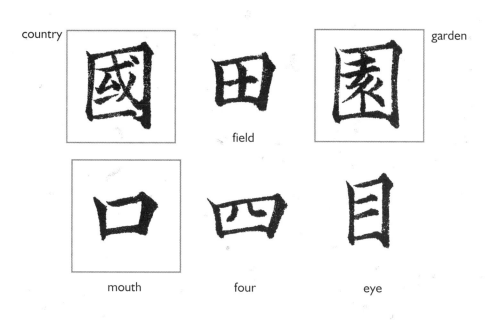

country

garden

field

mouth

four

eye

7 Fully enclosed characters

This type of character is completely enclosed as if by a wall, forming a square or a rectangle.

Take particular care with the size of such characters. More complex characters may be larger, with space within for all the strokes, creating a pleasing visual balance.

studio

precipice

turtle

worry

defeat

babble

8 Complex characters with multiple divisions

These characters look extremely complicated, but once you have mastered the other seven basic categories you should find it easier to understand their composition.

In some cases, the more complex a character, the easier it is to arrange the individual components. Some of the most difficult characters to write well are those with the fewest strokes!

Sequence of strokes

Before the invention of paper, Chinese books were made of long vertical strips of bamboo or wood. When a person wrote, the left hand held the strip and the right hand the brush, and so the most natural way was to write from the top downwards. However, because of the many different ways of composing characters, they are not all written from top to bottom. There are a variety of sequences for writing characters, some of them impossible to explain logically.

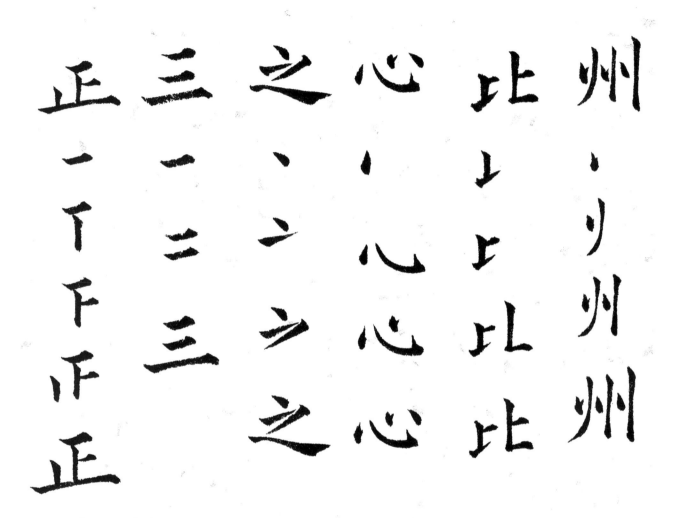

| upright | three | of | heart | compare | continent |

1 From top to bottom　　　　　　　　　　　　**2 From left to right**

| ten | king | year | person | heaven | today |

23

3 Horizontal then vertical

In characters where horizontal and vertical strokes cross each other, the horizontal stroke is usually made first. A horizontal stroke at the bottom of a character should be written last.

4 Left sweep then right

When a left and a right sweep occur as a pair, make the left one first.

Sequence of strokes

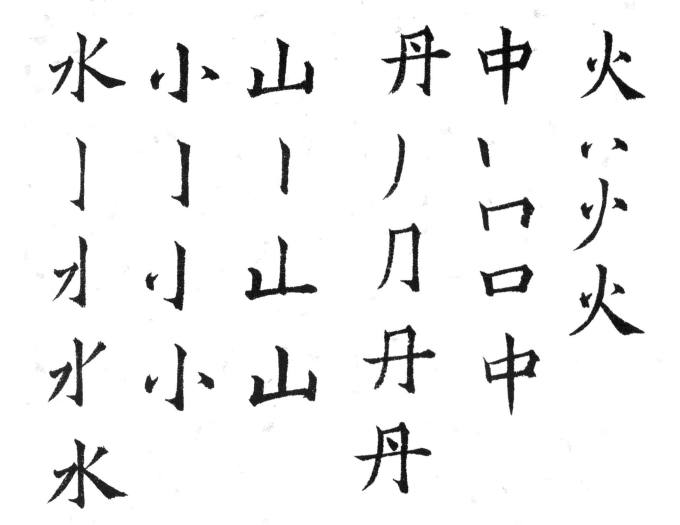

water small mountain red centre fire

5 From centre to sides

In some characters a major stroke
in the centre forms the spine.
This is always the first stroke.

6 From sides to centre

In some characters the centre
part, whether large or small, is
said to convey the spirit of the
character. In such cases this part is
made last.

月　風　　幽　道　　國　固

moon　　　wind　　　gloomy　　　way　　　country　　　solid

7 From outside to inside

When the enclosure is above the rest of the character, the enclosure is made first.

8 From inside to outside

When the enclosure is below the rest of the character, the enclosure is made last.

9 Top three sides, then inside then final enclosure

This sequence of strokes occurs fairly frequently. The purest example is the character for mouth (see page 21), which is fully enclosed but empty.

Practice paper

Special ruled paper is produced for the practice of Chinese calligraphy, and this can help you to compose well-balanced characters. This paper comes in two versions: one is called the star or *mi* 米 (rice) pattern and the other is known as the nine-square or nine-palace pattern.

You can practise directly on to such paper or use it as a guide underneath your practice paper.

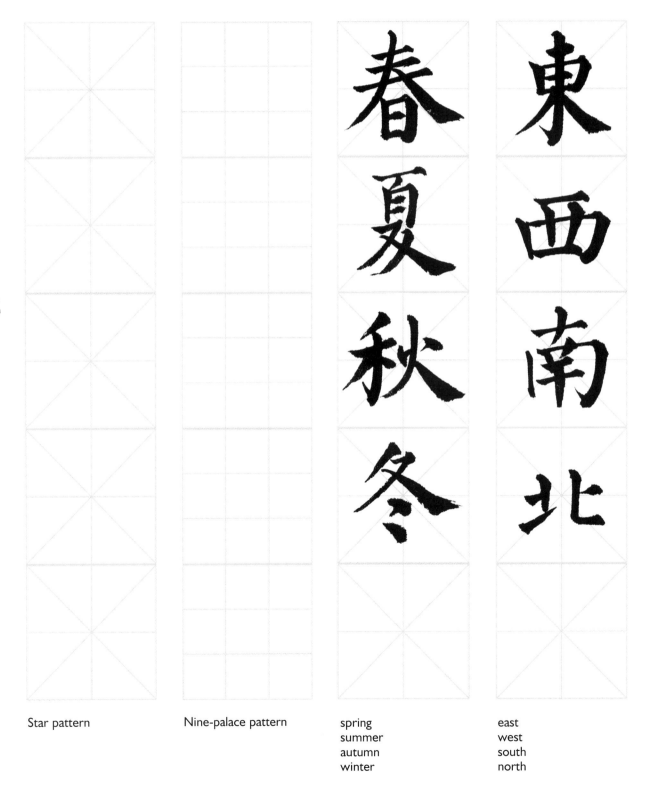

Star pattern

Nine-palace pattern

spring
summer
autumn
winter

east
west
south
north

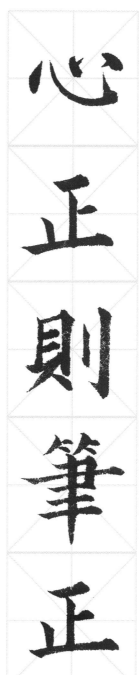

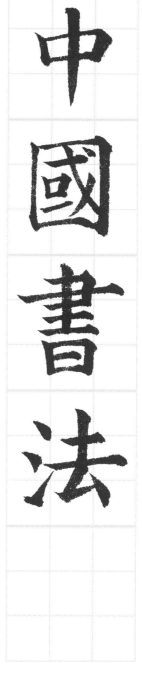

仁慈為賢

入木三分

心正則筆正

中國書法

The kindest is the wisest

Enter three *fen* deep into the wood (i.e. write with a powerful hand)

Sincerity makes for correct brushwork

Chinese calligraphy

先帝事有譏者
慮非今臣下所能
不與思省所示報

相舍崐崘之性不迷誤
天順地合藏精七日之奇
之何不守心曉根蒂養華
合九玉石落、是吾寶子

Zhong Yao (151–230) is known as the father of standard script. Tutor to the emperor Wei Mingdi, he researched calligraphy day and night. Even his bedclothes were torn because he scratched characters on them with his finger.

Wang Xizhi (303–61) is considered by many to be the greatest calligrapher of all time. His theories and his style of writing remain a powerful influence today.

28

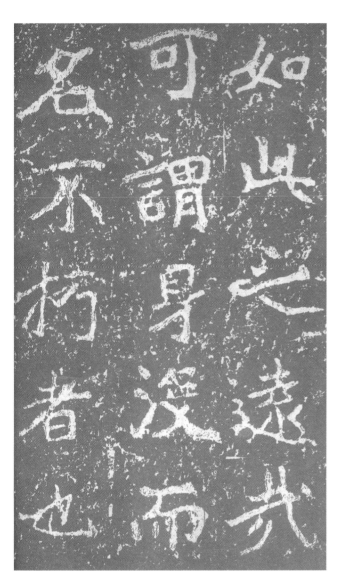

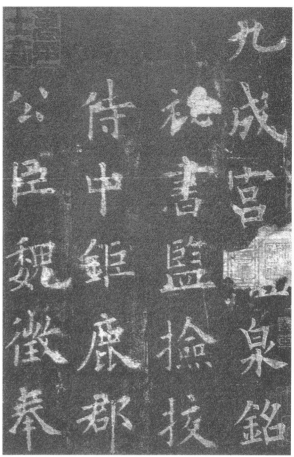

Zheng Daozhao (?–515)
reveals in his writing the link
between the official clerical
script of the Han dynasty and
standard script.

Ouyang Xun (557–641)
is one of the great
calligraphers of the early
Tang dynasty. His standard
script, known as the Ou
hand, ranks among the four
most important versions of
the script.

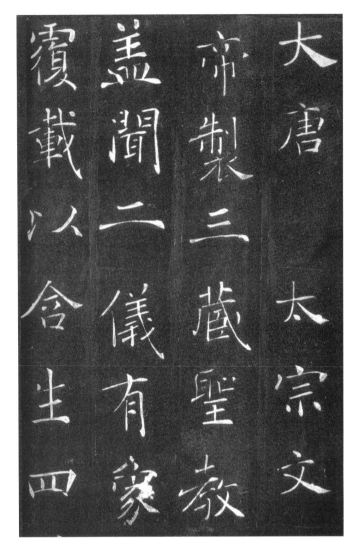

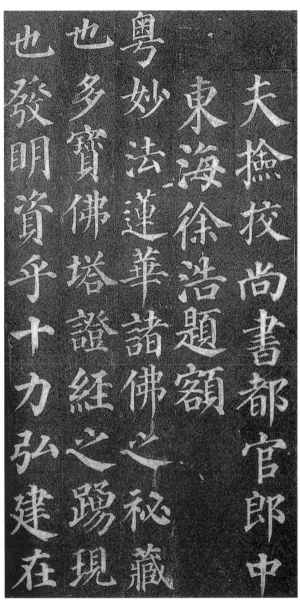

30

Chu Suiliang (596–658)
is another early Tang dynasty
calligrapher. His writing has
the appearance of being
delicate and sinuous, yet his
characters have an inner
strength and stability.

Yan Zhenqing (709–85)
is one of the greatest
calligraphers of the mid-Tang
dynasty. His writing is
upright, powerful and full of
integrity. Known as the Yan
hand, his is one of the four
most important versions of
standard script.

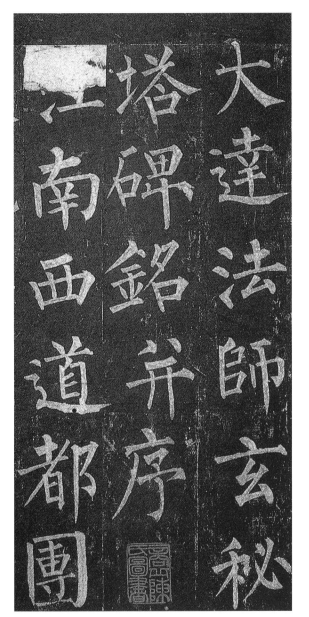

大達法師玄秘
塔碑銘并序
上南西道都
團

汲黯傳

汲黯字長孺濮陽人也其先有寵於古之
衛君至黯七世為卿大夫黯以父任孝景時
為太子洗馬以莊見憚孝景帝崩太子即
位黯為謁者東越相攻上使黯往視之不至
吳而還報曰越人相攻固其俗然不足以辱天子
之使河內失火延燒千餘家上使黯往視之還

Liu Gongquan (778–865)
is renowned for his powerful
calligraphy which is said to
have 'muscles of steel and
bones of iron'. He wrote the
famous words: 'Sincerity
makes for correct
brushwork'. The Liu hand is
another of the four most
important versions of
standard script.

Zhao Mengfu (1254–1322)
is the most famous
calligrapher of the Yuan
dynasty. The Zhao hand is
the latest of the four
important versions of
standard script and one of
the most popular styles in
use today.

31

Bibliography

Practical guides

Chiang Yee, *Chinese Calligraphy: An Introduction to its Aesthetic and Technique.*
London: Methuen and Co Ltd 1938

Dahlen, Martha, Grace Ho and Ho Siu Kei, *Brush with Life: Writing Chinese Words of Virtue and Celebration.*
Hong Kong: United Century Book Services Ltd 2002

Kwo Da-Wei, *Chinese Brushwork in Calligraphy and Painting.*
London: Dover 1981

Liu Puqing, *Standard Modern Chinese Calligraphy (Kaishu biaozhun zitie).*
Beijing: Beijing Press 1979

Qu Lei Lei, *The Simple Art of Chinese Calligraphy.*
London: Cico Books 2002

History and theory

Barrass, Gordon S., *The Art of Calligraphy in Modern China.*
London: The British Museum Press 2002

Billeter, Jean François, *The Chinese Art of Writing.*
New York: Skira/Rizzoli 1990

Fu Shen, *Traces of the Brush: Studies in Chinese Calligraphy.*
Yale University Press 1977

Lin Hongyuan, *Great Dictionary of Chinese Calligraphy (Zhongguo shufa dazidian).*
Beijing: Guanghua Press 1980

Moore, Oliver, *Reading the Past: Chinese.*
London: The British Museum Press 2000

Sun Xiaoyun, *The Way of Chinese Calligraphy (Shufa youfa).*
Beijing: Knowledge Press 2003

Yang Zaichun, *Handbook of Chinese Calligraphy (Zhongguo shufa gongju shouce).*
Beijing: The Physical Education Press 1987

Zhang Yiguo, *Brushed Voices: Calligraphy in Contemporary China.*
Columbia University 1998